LIFE ALONG THE RIO GRANDE

An exhibit of contemporary fiber art presented by
Studio Art Quilt Associates of New Mexico.

April 3-June 9, 2018: Branigan Cultural Center
501 N. Main St., Las Cruces, NM, 575-541-2154
Opening Reception, April 6, 2018, 5-8PM

June 23-August 4, 2018: First Unitarian Church
3701 Carlisle Blvd. NE, Albuquerque, NM
505-884-1801

October 1-November 19, 2018: Macey Center
1 Olive Lane, Socorro NM, 575-835-5688

**December 1, 2018-January 26, 2019: Roswell
Museum**
100 W. 11th St., Roswell, NM, 575-624-6744
Opening reception, December 1, 2018, 5-7PM

Curated by Betty Busby

FROM THE CURATOR

Life Along the Rio Grande was conceived as an opportunity for artists along the river's route to express their feelings and thoughts about whatever aspect of the river sparked their creativity.

The response ranged from representational to abstract, including historical, scientific and geographical references, all while working within given size parameters.

A wide variety of techniques was used, from traditional piecing, hand stitching and appliqué, to the newest synthetics and non woven fabrics.

The finest silk was used in some of the pieces, others had hand dyed cottons, commercial prints and found objects which demonstrates the huge range of fiber materials that can be combined in today's art quilt.

We hope you enjoy this exhibit as much as we did in creating the work and putting the show together.

Many thanks go to Shannon and Vicki Conley for originating the theme, and their tireless work in securing the venues and creating all of the promotional material.

Our New Mexico area representatives Lynn Rogers and Gale Oppenheim-Pietrzak have also played a vital role in organizing our members; their efforts are much appreciated.

-Betty Busby, Curator

Cover artists: Mary Jo Stipe, Bev Haring, Char Punke, Lynn Welsch, and Judith Roderick

Studio Art Quilt Associates

SAQA is an international non-profit organization dedicated to promoting the art quilt and the artists who create them. We are an information resource on all things art quilt related for our members as well as the public. Founded in 1989 by an initial group of 50 artists, SAQA members now number more than 3,400 artists, teachers, collectors, gallery owners, museum curators and corporate sponsors. For more information, visit the organization's website at SAQA.com.

FROM THE EDITOR

The Rio Grande supports a vast diversity of life as it travels through the American Southwest from its headwaters in the mountains of Colorado to the Gulf of Mexico. As I went through the quilts in preparation for designing the catalog, thematic groups began to emerge. Some artists focuesd on the river itself, while others depicted aspects of the varied ecosystems surrounding the Rio Grande, and still others seemed to draw inspiration from people and their connections to the river.

-Shannon Conley

CONTENTS

The Ecosystems

The People

SANDBAR

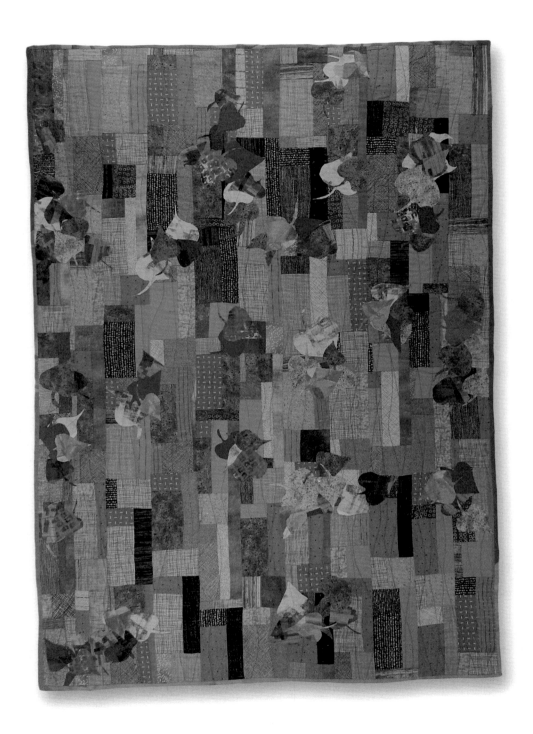

Ann Anastasio

Santa Fe, NM

aanastasio@comcast.net

"Sandbar" represents the shifting sands in the shallow Rio Grande, often separated by small, irregular rivulets of sparkling water. The background is machine pieced and quilted using sandy brown and beige cottons in an original rectangular pattern with a few slender slivers of shades of aqua inserted. The scattered cottonwood leaves are fused and sewn after quilting.

RIVER

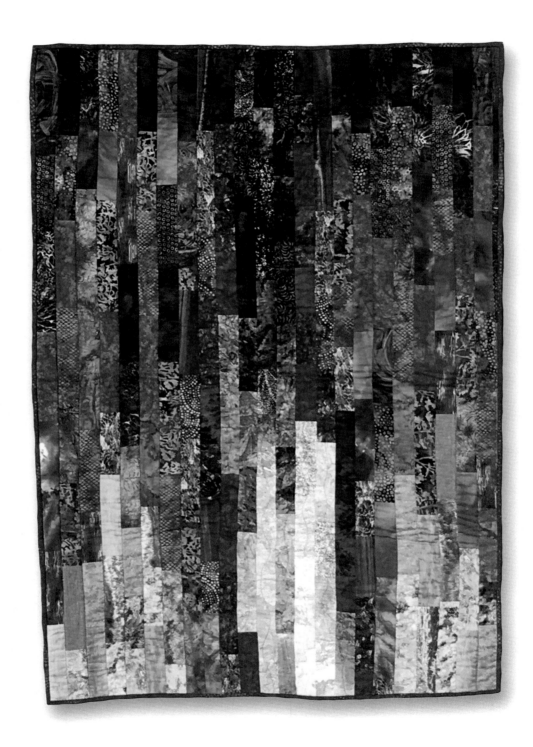

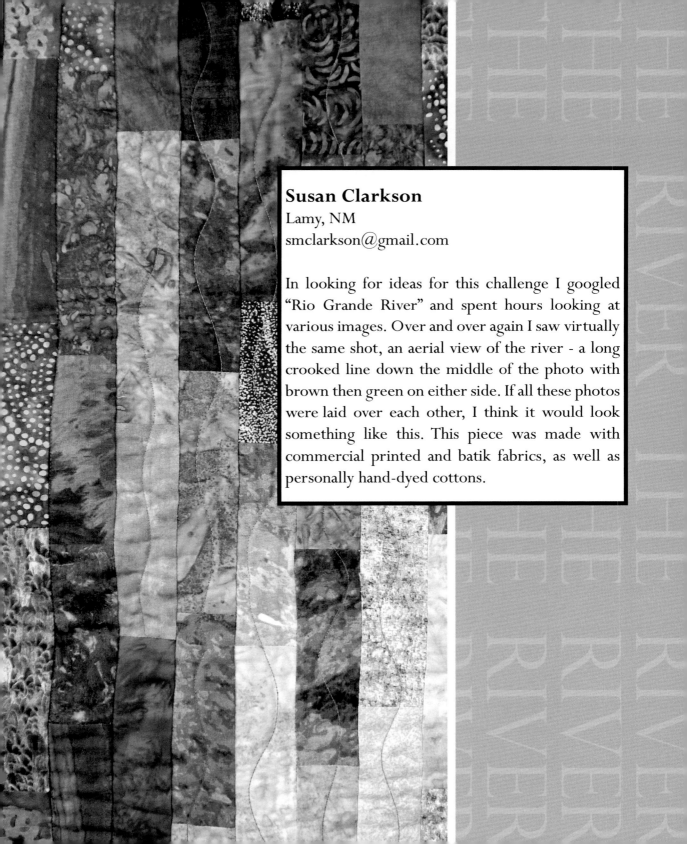

Susan Clarkson
Lamy, NM
smclarkson@gmail.com

In looking for ideas for this challenge I googled "Rio Grande River" and spent hours looking at various images. Over and over again I saw virtually the same shot, an aerial view of the river - a long crooked line down the middle of the photo with brown then green on either side. If all these photos were laid over each other, I think it would look something like this. This piece was made with commercial printed and batik fabrics, as well as personally hand-dyed cottons.

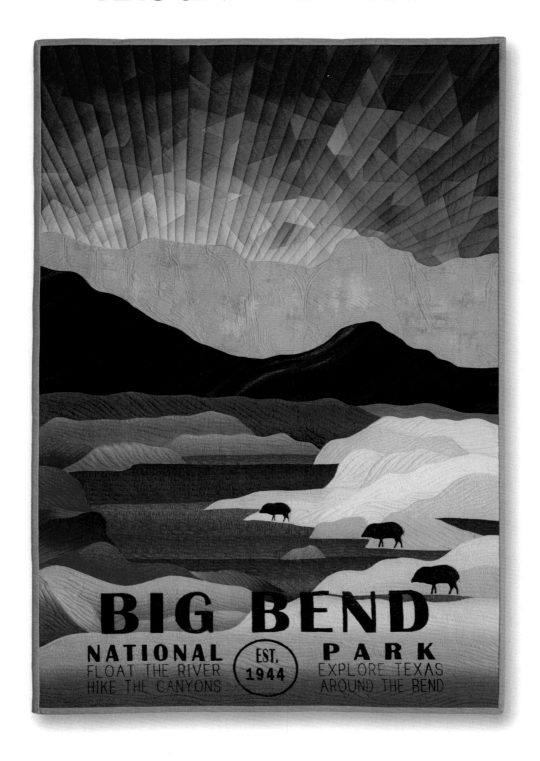

Vicki Conley
Ruidoso Downs, NM
vickiconley55@gmail.com
vicki-conley.com

The beautiful area along the Rio Grande at the Big Bend is teeming with biological, geological, and cultural diversity. One can float the river which defines our border with Mexico, hike in the high mountains, or just enjoy the radiant landscape. You might even be surprised by a javelina. Come see one of America's least visited national parks.

MEANDERING RIVER

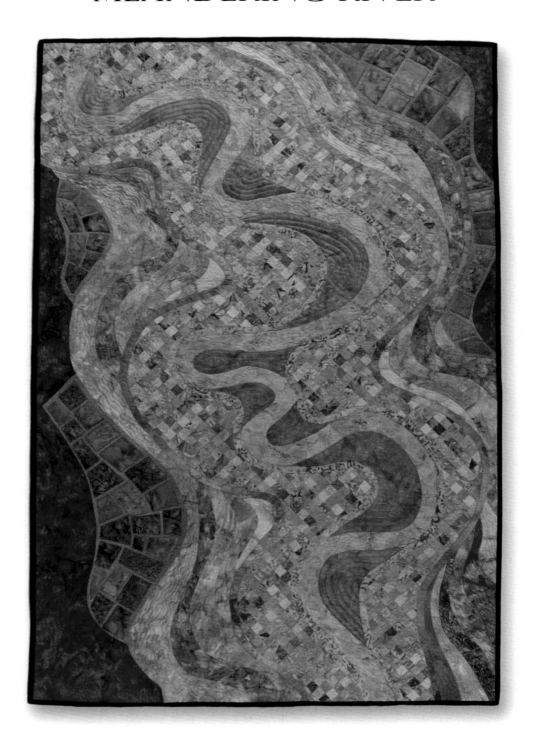

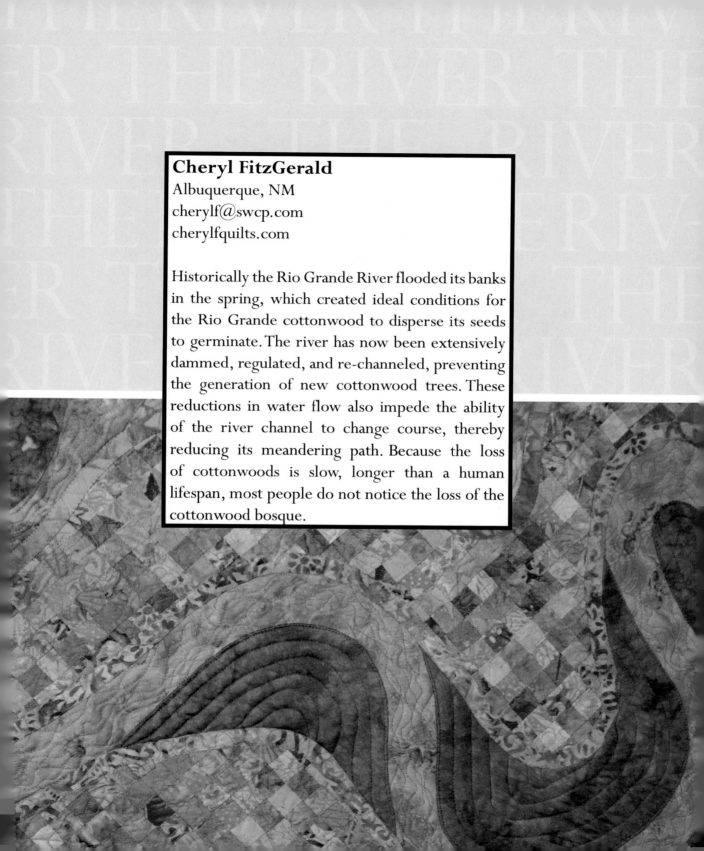

Cheryl FitzGerald
Albuquerque, NM
cherylf@swcp.com
cherylfquilts.com

Historically the Rio Grande River flooded its banks in the spring, which created ideal conditions for the Rio Grande cottonwood to disperse its seeds to germinate. The river has now been extensively dammed, regulated, and re-channeled, preventing the generation of new cottonwood trees. These reductions in water flow also impede the ability of the river channel to change course, thereby reducing its meandering path. Because the loss of cottonwoods is slow, longer than a human lifespan, most people do not notice the loss of the cottonwood bosque.

ENCHANTED RIO GRANDE: EARTH, SKY AND WATER

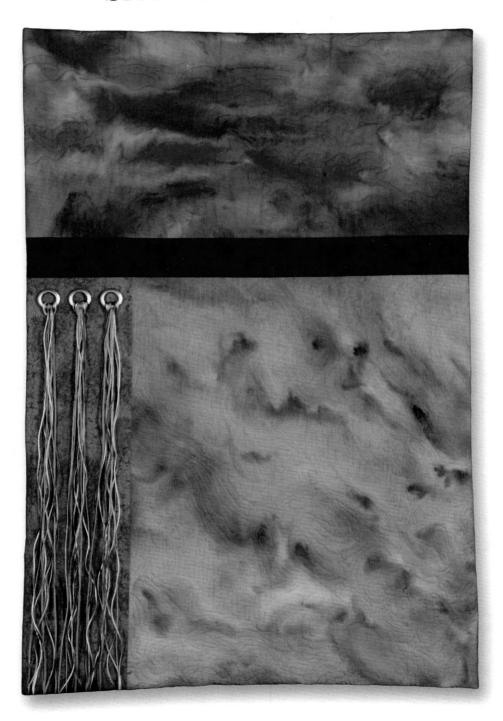

Cynthia Fowler
Santa Fe, NM
CLFJAM-Cindy@yahoo.com

I am blessed to live in the desert southwest where the landscape and sky are ever changing and always beautiful. I chose to use strips and splashes of color to evoke the feel of what I see out of my window each day: the subtle colors of the land, the blue-purples of the mountains, the brown river bed that (sometimes) has flowing water, and the fantastically beautiful sunrises and sunsets. Hand painted and commercial cottons, machine pieced and quilted, hand embellished.

MAPFORMS #11

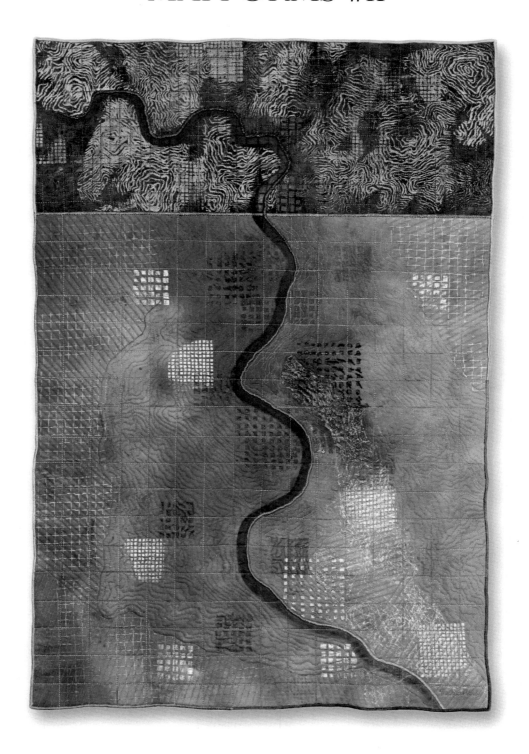

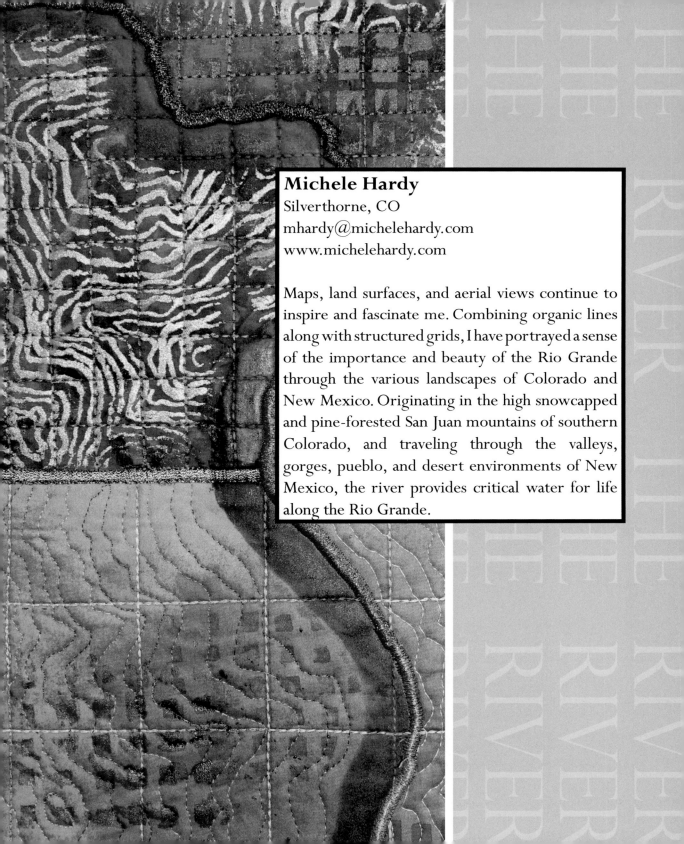

Michele Hardy

Silverthorne, CO
mhardy@michelehardy.com
www.michelehardy.com

Maps, land surfaces, and aerial views continue to inspire and fascinate me. Combining organic lines along with structured grids, I have portrayed a sense of the importance and beauty of the Rio Grande through the various landscapes of Colorado and New Mexico. Originating in the high snowcapped and pine-forested San Juan mountains of southern Colorado, and traveling through the valleys, gorges, pueblo, and desert environments of New Mexico, the river provides critical water for life along the Rio Grande.

HEADWATERS

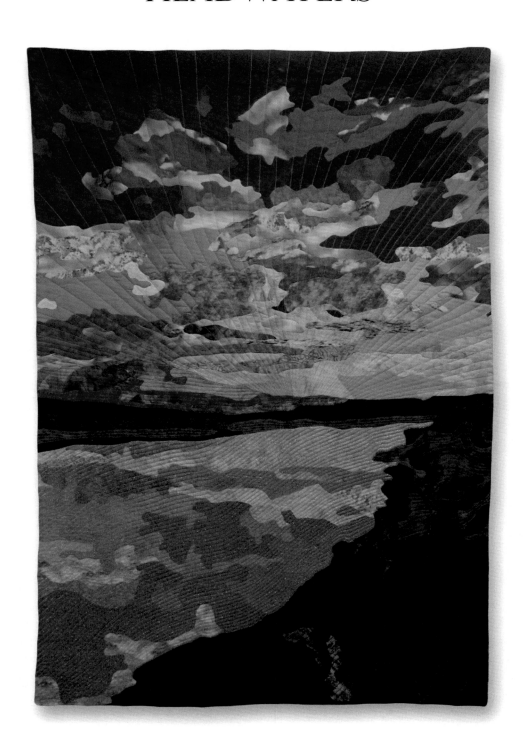

Bev Haring
Longmont, CO
webspinner51@yahoo.com

At the top of the Rocky Mountains the mighty Rio Grande begins as a little creek, and in the light of sunset, it seems to glow.

LIVE WATER

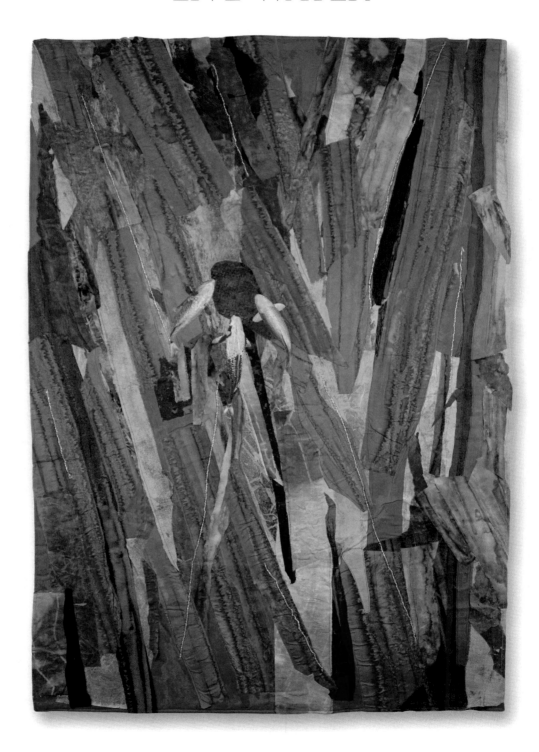

Mary Olivea

Santa Fe, NM

moliveanm@gmail.com

Live Water. A precious commodity in New Mexico. It means water that moves, not a puddle. The Rio Grande cuts down the middle of New Mexico giving life to fish, fields, animals, and man. When it turns east to begin its push to the Gulf of Mexico it becomes its most notorious--our border with Mexico. I used tissue paper to create the sense of depth of the river, cotton fabric for its movement and structure, beads for sparkle, and the fish were an afterthought for a stronger focal point. Glued, stitched and quilted.

LIFE BLOOD

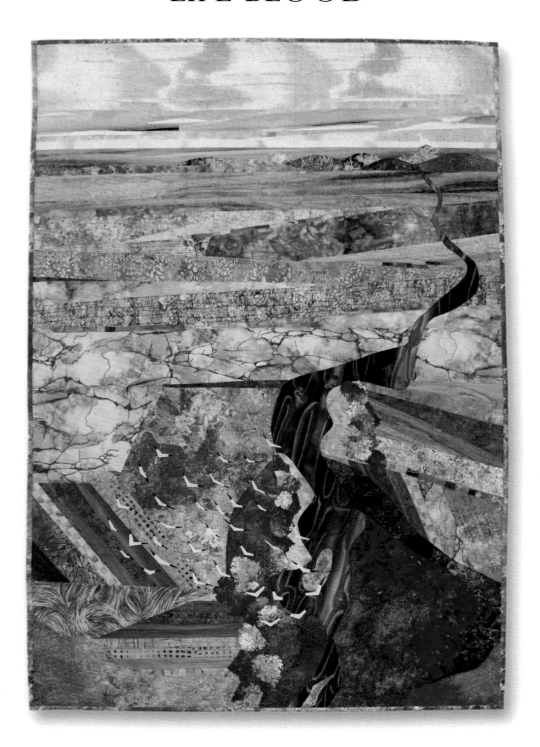

Char Punke

Albuquerque, NM
charpunke@gmail.com

Visiting the Rio Grande, I am always amazed at all the activity in the river and along its shores. For all of its history this river has generated life. Without the river, New Mexico, Colorado, and Texas might have remained a desert. There would have been no development, no pueblos, no diversity of plant and animal life, no fish in its water, few insects and a limited number of bird species. Through my representational art I wish to portray different aspects of its journey from the mountains to the valleys. The Rio Grande river truly is the life blood of this land.

LAYERED LANDSCAPE

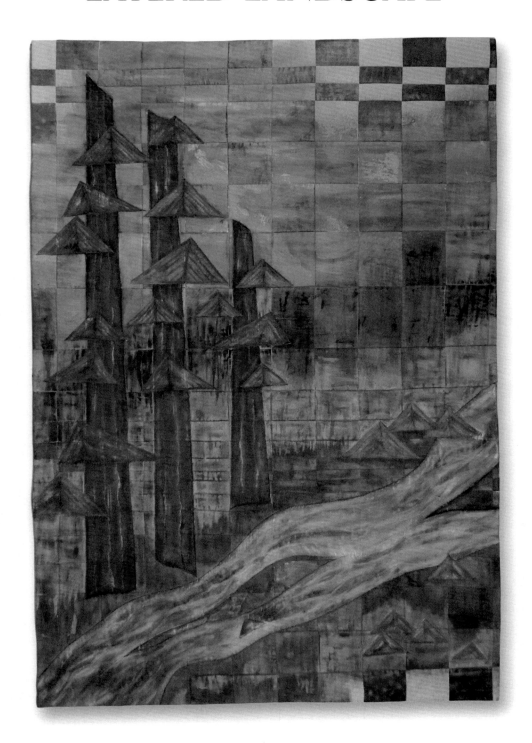

Karen Stalgren

Frederick, CO

hkstalgren@q.com

The Rio Grande river, from turbulent head waters to gentle flowing terminus, has always fascinated me. Using a traditional quilt as a canvas, I applied paint in multiple layers to represent the rich rugged textural quality of the rock and rushing water. The ponderosa pine is a vertical counterpoint to the horizontal layers of rock.

IN THE BEGINNING

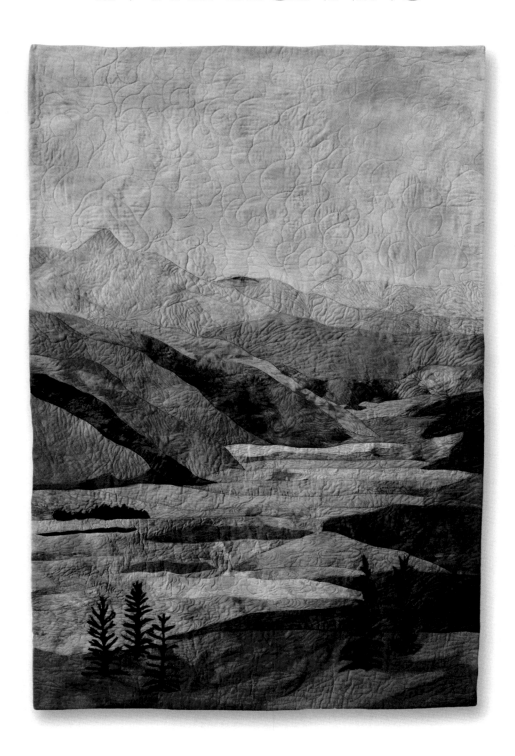

Gay Young
Sweetwater, TX
gayyoungart@gmail.com
www.gayyoungart.com

Our mighty Rio Grande begins life as snow melt in the mountains of Colorado. This piece is based on a photo I took in the mountains above Creed, Colorado.

THE ANTS…

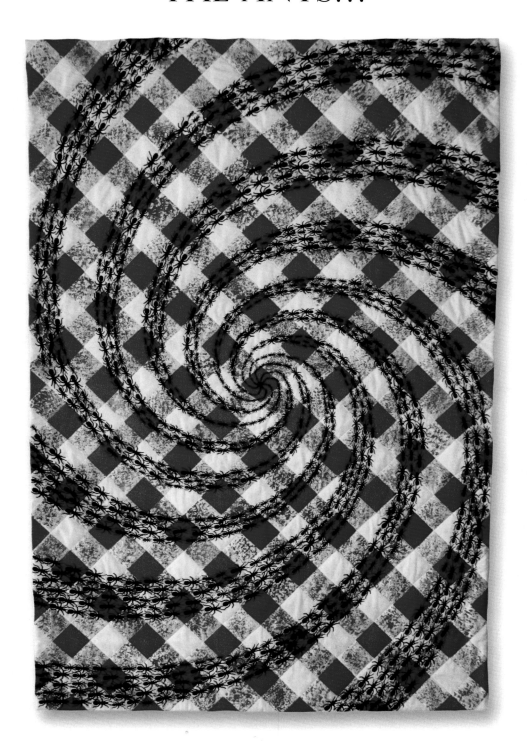

Schatzi Brimer

Santa Fe, NM
sbrimer101@gmail.com

Life is abundant along the Rio Grande and includes a variety of plants and animals. Wildlife is diverse and includes fish, birds, coyotes, deer, squirrels, rabbits, skunks, bobcats, ocelots, foxes, opossums, shrews, lizards, snakes, bats and mice - just to name a few. On a smaller scale you will find a whole other ecosystem consisting of a variety of insects. The ants are among them and can be found all along the river. Picnic anyone?

LILY POND AT SHADY LAKES

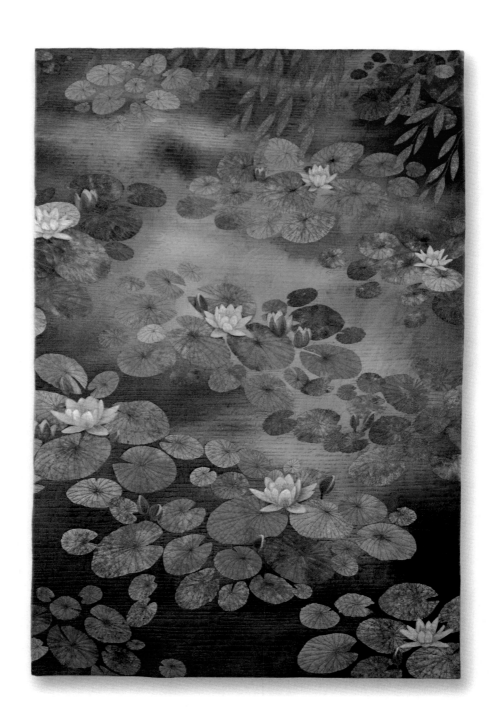

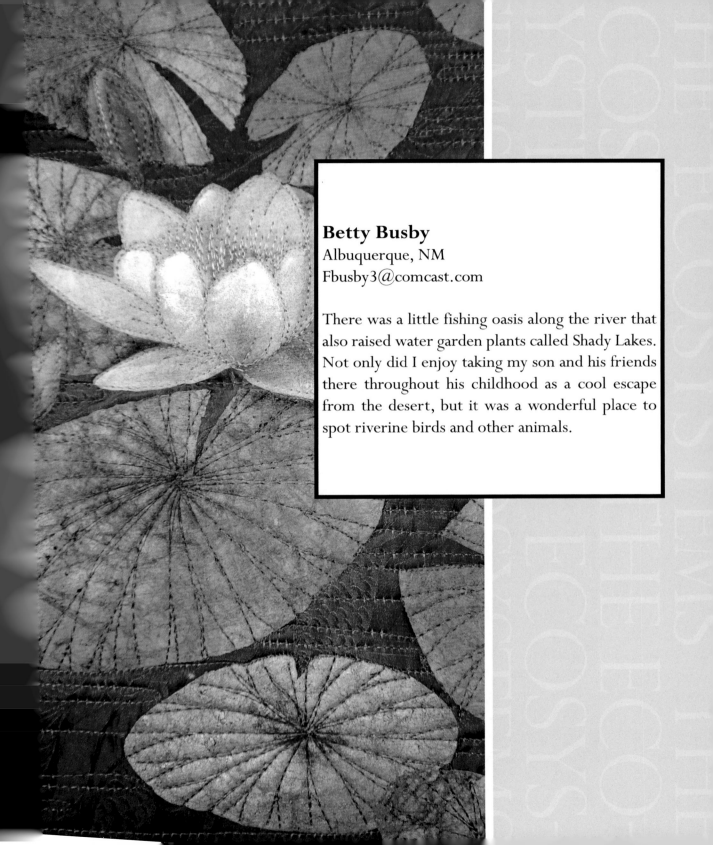

Betty Busby
Albuquerque, NM
Fbusby3@comcast.com

There was a little fishing oasis along the river that also raised water garden plants called Shady Lakes. Not only did I enjoy taking my son and his friends there throughout his childhood as a cool escape from the desert, but it was a wonderful place to spot riverine birds and other animals.

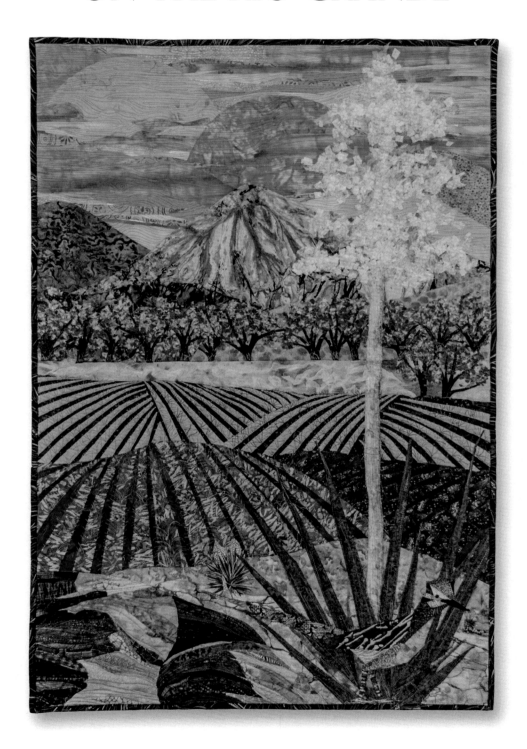

ECOSYSTEMS

Nicole Dunn

Los Alamos, NM
nicole@dunn-nm.com
www.dunnquilting.com

I was inspired by a recent trip taken to the southern part of New Mexico as well as living alongside the Rio Grande for most of my life. The sights, sounds, colors and textures of this river and its surroundings are always a source of inspiration for my work.

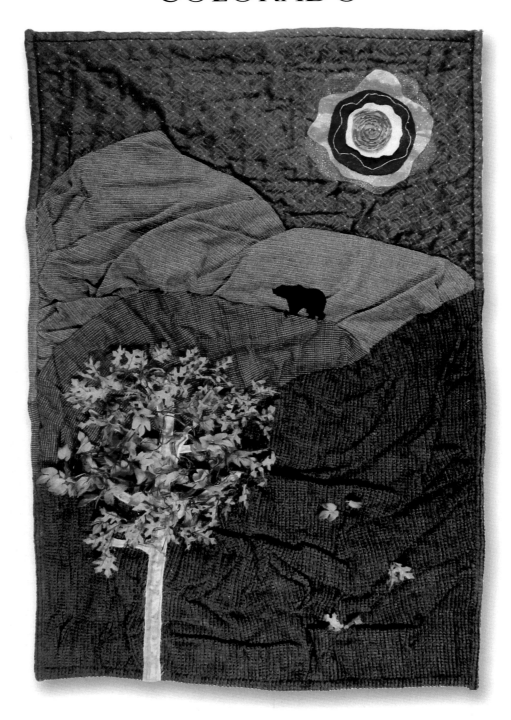

Theresa Maguire Ely
Gunnison, CO
treasuresbytree@gmail.com
treasuresbytree.etsy.com

This art quilt was created using non-traditional quilting fibers. As I experimented with using upholstery fabrics, I realized that these fibers added dimensionality and texture that you can't get with lighter materials, adding to the character of this quilt. Some challenges were introduced, as I folded and twisted the material to create the mountains it became bulkier and harder to quilt. Then I used organza and tulle to create the sun and finalized the scene with the bear and the leaf vine. Voila, the hillside came alive with color, texture and depth!

OASIS

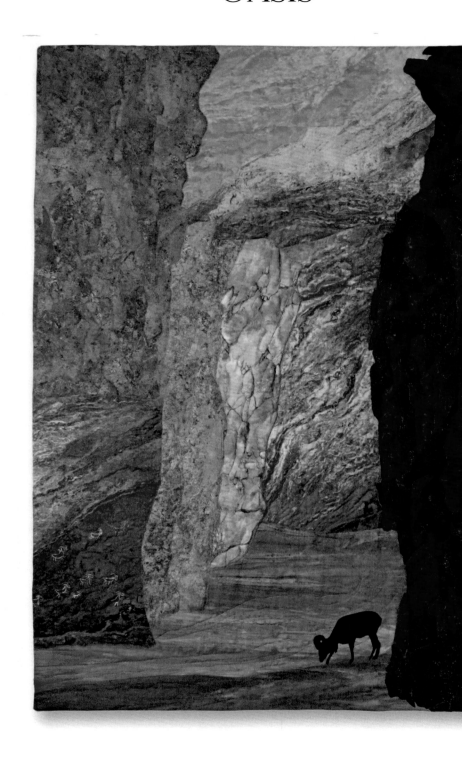

Ginny McVickar
Pleasant Hill, OR
mcvickarg@gmail.com
www.timelessarts.blogspot.com

The long stretch of the Rio Grande winds over open land and slides between the high canyon walls where the sun barely penetrates. The shade of the walls cools the water flow, creating an oasis for wildlife in the hottest seasons of the year. Wildlife sense the location of water and have for ages, as evidenced by the petroglyphs etched into the rock hundreds of years in the past.

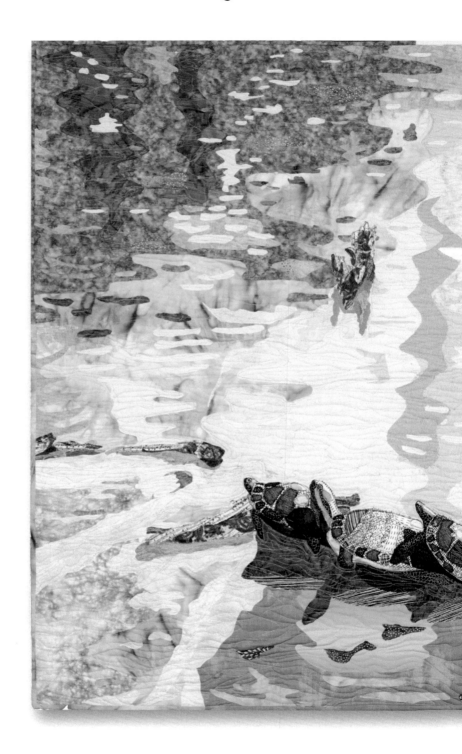

Anne Moats

Albuquerque, NM
anne.moats001@comcast.net

Nothing is as peaceful as the red slider turtles sunning themselves perched on a log in a pond at the Rio Grande Nature Center State Park. The surrounding cottonwood trees are reflected on the pond's surface.

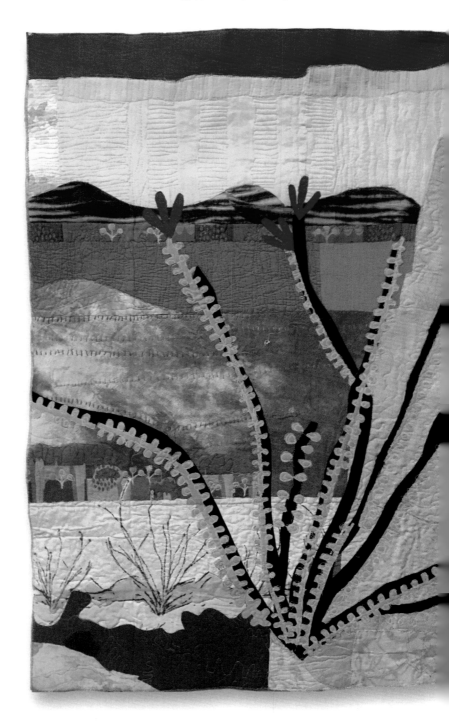

Susie Monday

Pipe Creek, TX
susieimonday@gmail.com
www.susiemonday.com

In 2016, I worked on an extensive series of art quilts inspired by the Big Bend area after several visits there for photographs, sketching, and hiking. This is one of the resulting pieces, actually cut from a much larger diptych. The cholla is in leaf and blooms only after rain. As the region faces uncertain impact from governmental policies of Donald Trump, I worry how long this plant and the delicate environment dependent on the river will survive.

COTTONWOOD

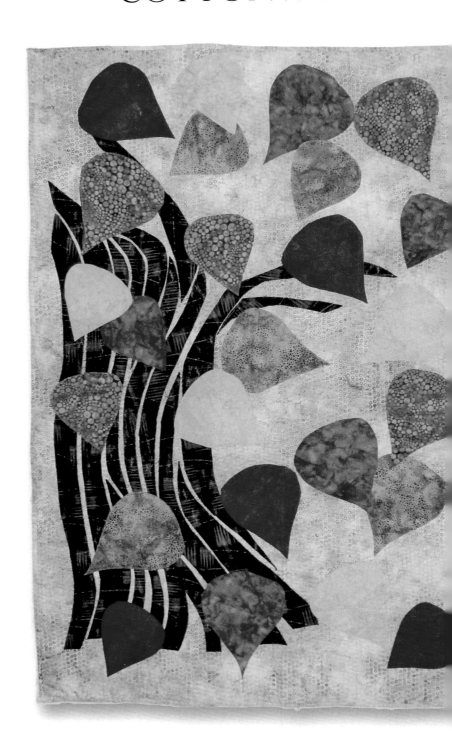

Gale Oppenheim-Pietrzak
Santa Fe, NM
goppie@sbcglobal.net

Everywhere I look are the colors of the cottonwood trees in various stages of the seasons. I like simplicity, design, and color. I matched the leaves' colors in my quilt to the actual cottonwood leaves that I have picked up in northern New Mexico. I visited quilt stores with my bag of leaves matching colors.

SANDHILL SUNSET

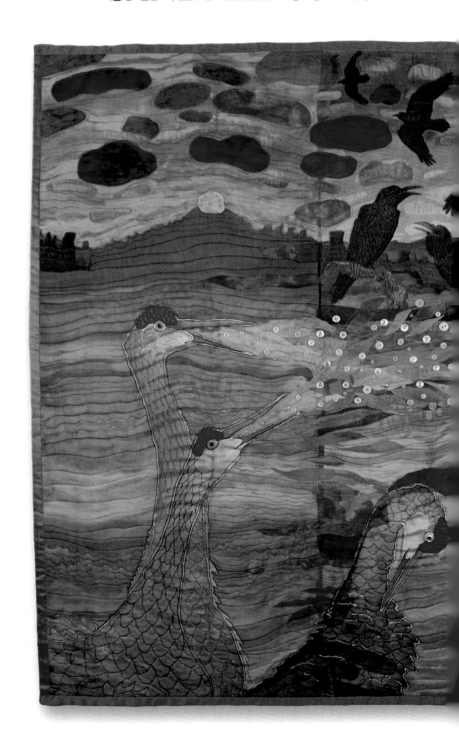

Judith Roderick

Placitas, NM

rainbowpaintr@comcast.net

Along the Rio Grande, from late October until February, one can often find sandhill cranes. You may hear them before you see them, making their distinctive warbling sound that Aldo Leopold called "the trumpet in the orchestra of evolution". This hand-painted silk quilt depicts them calling and preening, at sunset, as they roost in shallow water along the river.

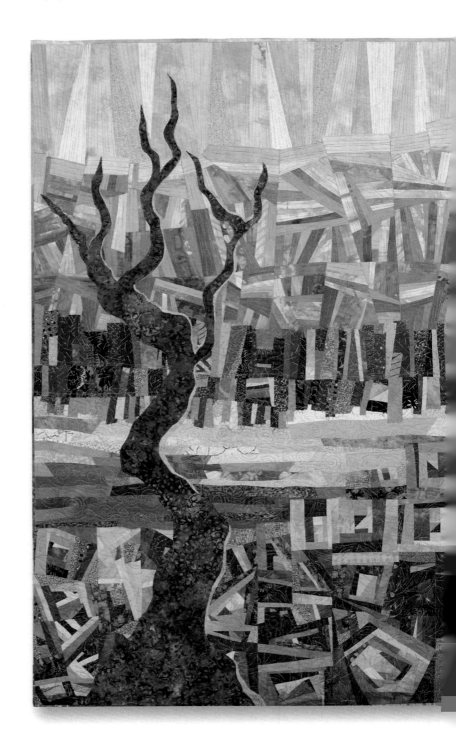

Lynn Rogers
Rio Rancho, NM
kblr049@aol.com

Along the Rio Grande in Albuquerque, a huge mountain rises from the valley floor. At sunset, the granite sparkles with a pink glow, giving this distinct geological feature its name: The Sandia, a Spanish word for watermelon. Also called Bien Mur, Big Mountain, by the Sandia Pueblo Indians, it's a special place for all who live nearby. Its Wilderness designation provides a sanctuary for those who seek a quiet place in the ever increasing traffic and noise of a growing urban center.

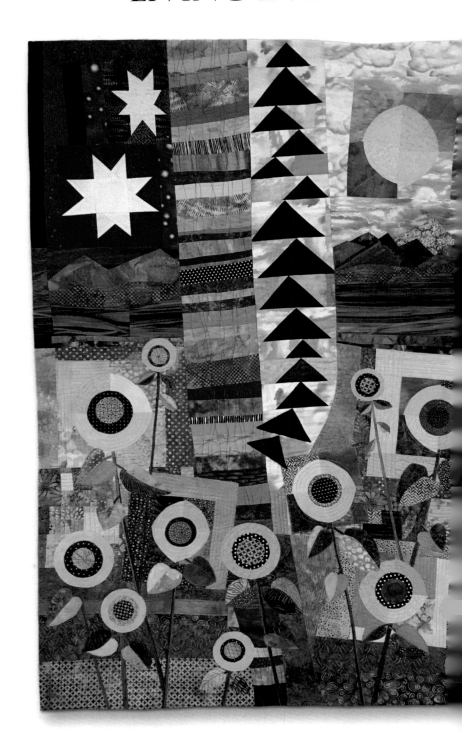

Mary Jo Stipe
Lamy, NM
maryjstipe@yahoo.com

Living in Lamy is an abstract ode to life in New Mexico. I never tire of the star-filled skies at night, days of dazzling sunshine, or the all-important monsoons of summer. Flights of ravens, mountain views and a seemingly endless landscape of spring and summer wildflowers delight my eyes and lift my spirits. Like most of my art quilts, this one was created with improvisational piecing and fused appliqué and machine quilted. I begin with a general idea or theme, and build it block by block, section by section. Each quilt is a new journey.

BIRD LANDS

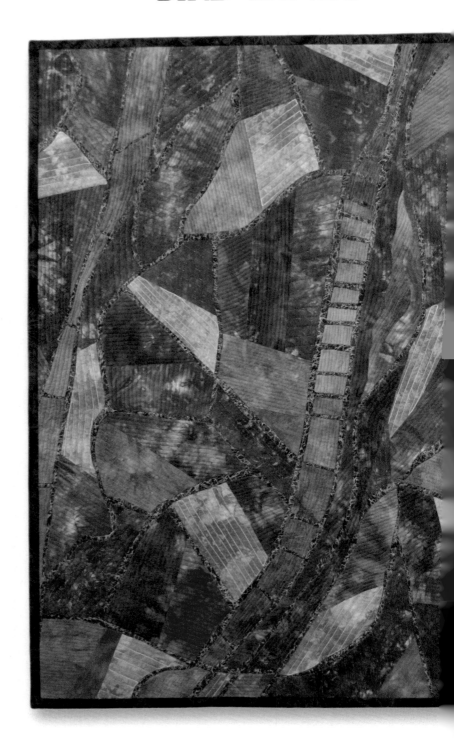

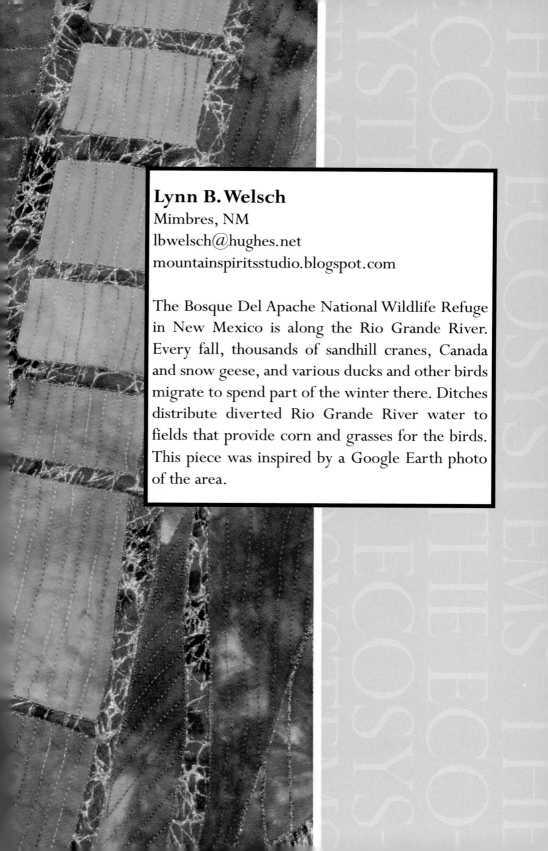

Lynn B. Welsch

Mimbres, NM
lbwelsch@hughes.net
mountainspiritsstudio.blogspot.com

The Bosque Del Apache National Wildlife Refuge in New Mexico is along the Rio Grande River. Every fall, thousands of sandhill cranes, Canada and snow geese, and various ducks and other birds migrate to spend part of the winter there. Ditches distribute diverted Rio Grande River water to fields that provide corn and grasses for the birds. This piece was inspired by a Google Earth photo of the area.

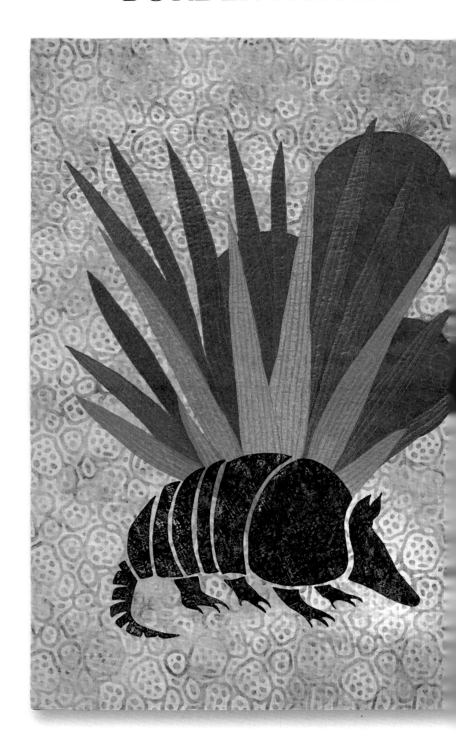

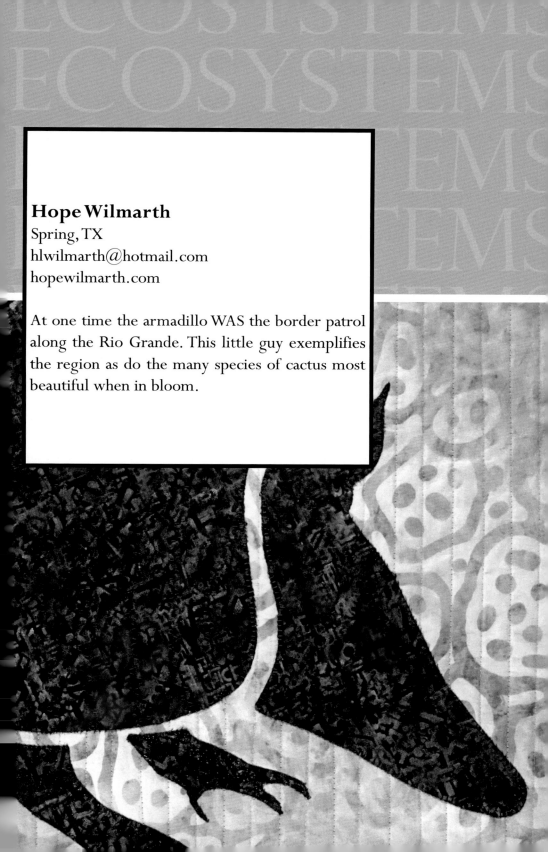

Hope Wilmarth

Spring, TX

hlwilmarth@hotmail.com

hopewilmarth.com

At one time the armadillo WAS the border patrol along the Rio Grande. This little guy exemplifies the region as do the many species of cactus most beautiful when in bloom.

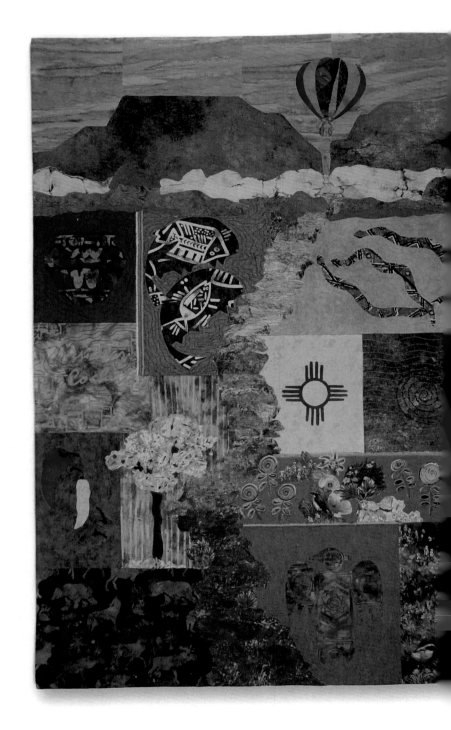

Carolyn Castaneda

Santa Fe, NM

nmartscapes@yahoo.com

There are many iconic images that represent life on the Rio Grande River. These range from ancient drawings on pottery and petroglyphs to animal and plant life. People living along the Rio Grande have also lived in pueblos which remain a popular style of home throughout New Mexico.

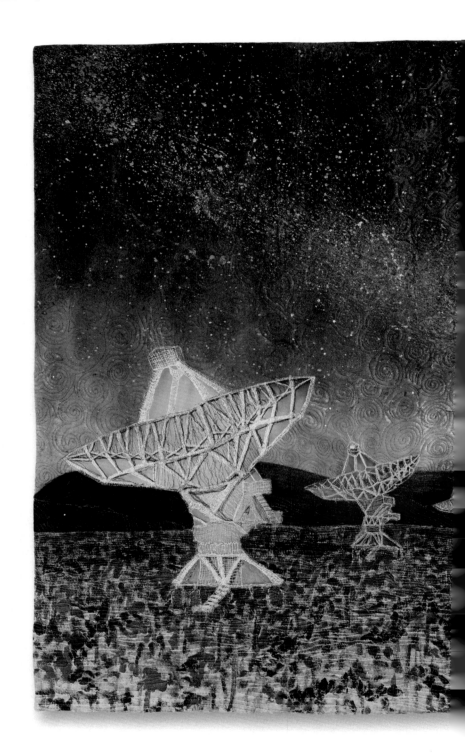

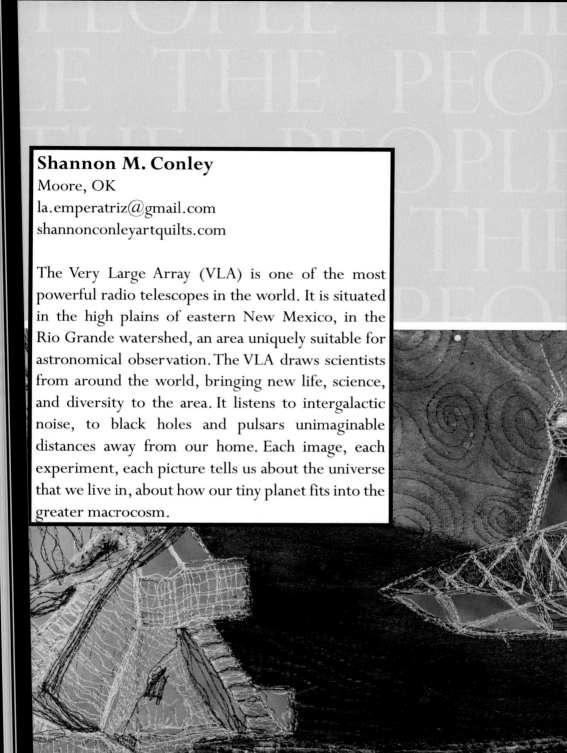

Shannon M. Conley

Moore, OK

la.emperatriz@gmail.com

shannonconleyartquilts.com

The Very Large Array (VLA) is one of the most powerful radio telescopes in the world. It is situated in the high plains of eastern New Mexico, in the Rio Grande watershed, an area uniquely suitable for astronomical observation. The VLA draws scientists from around the world, bringing new life, science, and diversity to the area. It listens to intergalactic noise, to black holes and pulsars unimaginable distances away from our home. Each image, each experiment, each picture tells us about the universe that we live in, about how our tiny planet fits into the greater macrocosm.

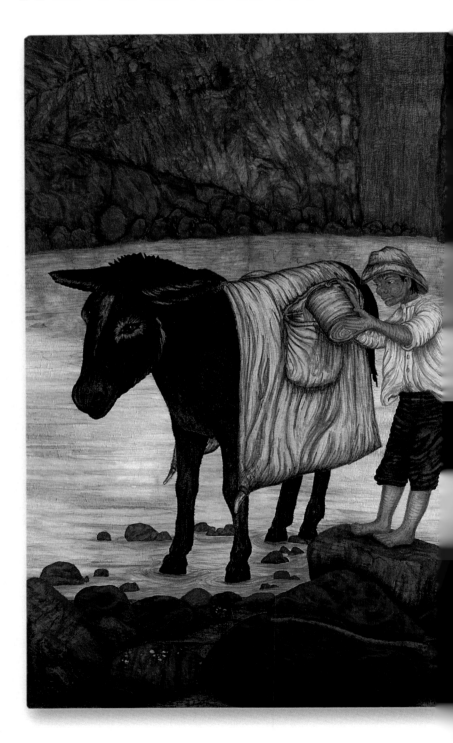

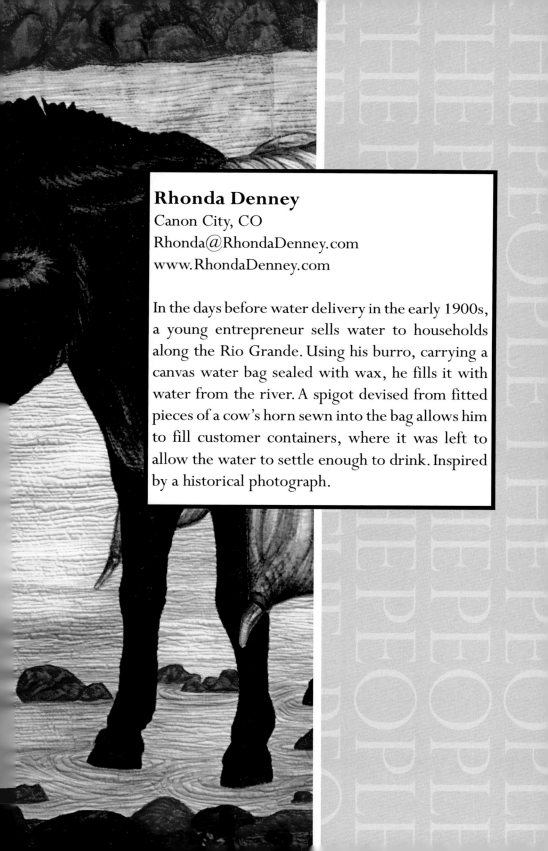

Rhonda Denney

Canon City, CO
Rhonda@RhondaDenney.com
www.RhondaDenney.com

In the days before water delivery in the early 1900s, a young entrepreneur sells water to households along the Rio Grande. Using his burro, carrying a canvas water bag sealed with wax, he fills it with water from the river. A spigot devised from fitted pieces of a cow's horn sewn into the bag allows him to fill customer containers, where it was left to allow the water to settle enough to drink. Inspired by a historical photograph.

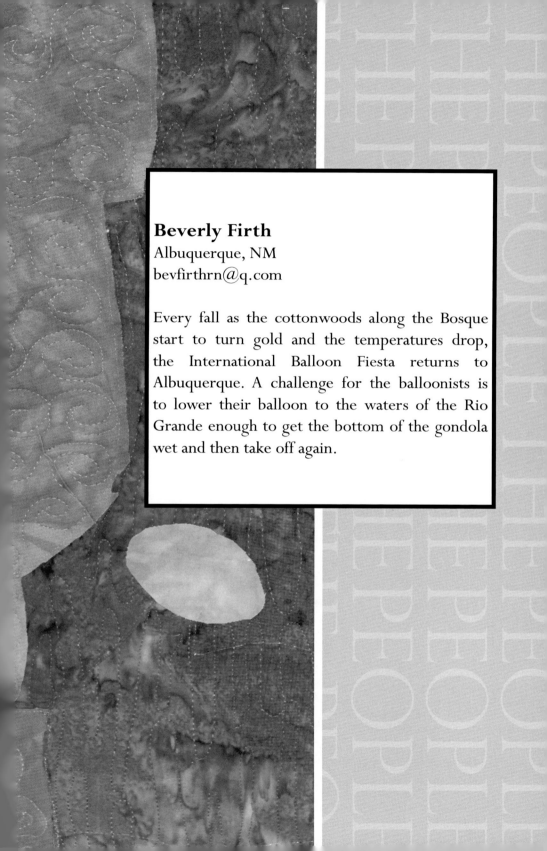

Beverly Firth
Albuquerque, NM
bevfirthrn@q.com

Every fall as the cottonwoods along the Bosque start to turn gold and the temperatures drop, the International Balloon Fiesta returns to Albuquerque. A challenge for the balloonists is to lower their balloon to the waters of the Rio Grande enough to get the bottom of the gondola wet and then take off again.

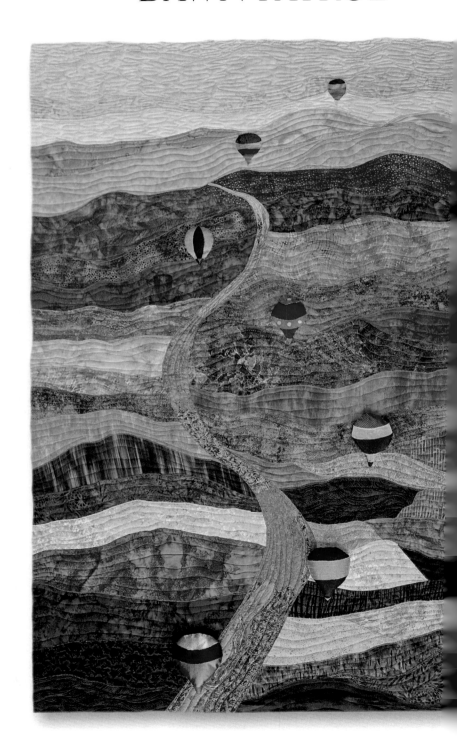

April Whiteside Foster

Santa Fe, NM

aprilspring43@msn.com

This piece was inspired by the aerial shots from the 2017 Balloon Fiesta. The pictures of the Bosque, the Rio Grande and the beautiful October scenery for a background were beautiful this year. I wanted to show the diverse landscapes of New Mexico and the beauty of the river as it goes from the green valleys to the northern mountains. Imagine floating above all this silently-what a wonderful chance to show our land to visitors from around the world so they can see the truly magical place where we live every day.

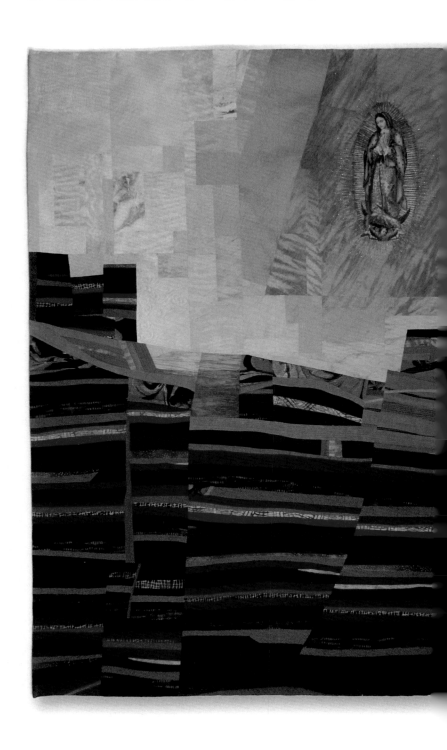

Diana Fox
Denver, CO
Hiitsdi58@msn.com
contemporaryquilter.com

This year I had the opportunity to drive from Denver to Texas for a week's stay. I noticed how many tributes to the Lady of Guadalupe were lovingly placed along my route through the Rio Grande valley. Faith, culture, and daily life come together in this magical and beautiful land.

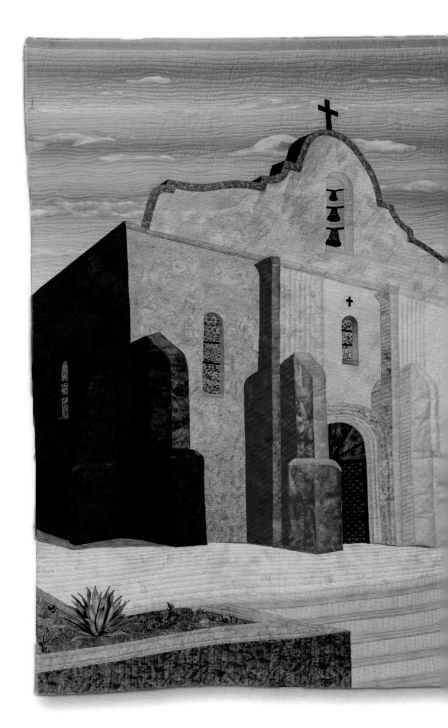

Elaine Hengen
El Paso, TX
elainehengen@gmail.com

The Presidio Chapel of San Elizario, Texas was first established in 1789 within a Spanish military garrison. Today, the church is part of the El Paso County Mission Trail and is an important part of the lives of those living along the Rio Grande. My work as an attorney providing legal services to the City of San Elizario inspired me to create my version of the current stark white adobe building built in 1877. Eighty different fabrics, Fabrico markers and Inktense pencils were used to achieve the flowing colors. Trapunto work helps define the structural elements.

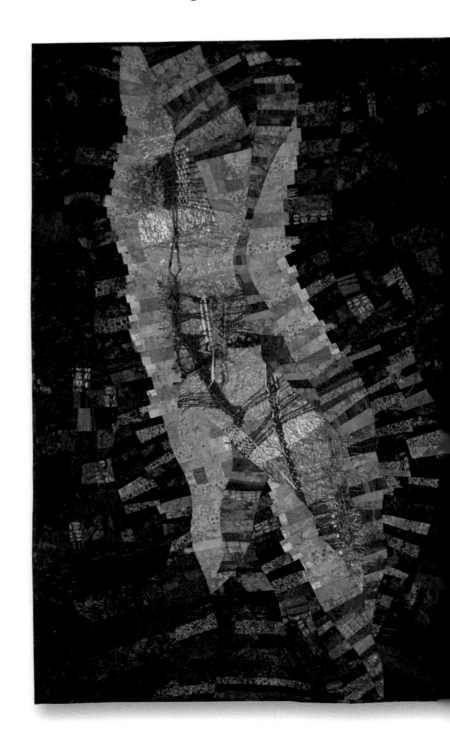

Michelle Jackson

Sandia Park, NM

michellejackson@quiltfashions.com

www.quiltfashions.com

There is nothing like the turquoise found along the Rio Grande. This piece depicts a vein of turquoise in the earth, here done with weaving of yarns threads and ribbons. It is entirely pieced and machine quilted.

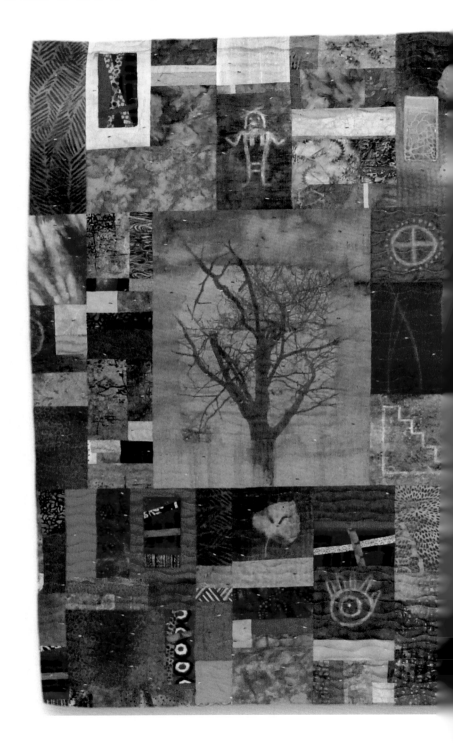

;ue Lewis

.rvada, CO

ızqvb@aol.com

ıstudioblog@wordpress.com

1y work is largely inspired by traditional quilts and
1e beauty of nature. I use a wide variety of textiles,
ıcluding vintage kimono silk, upholstery, hand-dyed
.bric, hand painted fabric and organza. I incorporate
ound objects, wire, feathers, mica as well as linens
ıd papers preserved by my family. My intention is to
·oke a mood or elicit a memory and push the image
· the abstract by transparent layering and intuitive
ımposition and color. The Japanese concept of "wabi-
bi" or the imperfection of nature, is something I value.
·xture is an element pursued and created by a variety of
ıers and threads. I use both machine and hand stitching
ı hand dyed or eco-dyed fabric to honor natural beauty.

Mary Mattimoe
Newmarket, England
mmattimoe3@gmail.com
www.marymattimoe.com

The River of Empires pays tribute to one of the best albums ever recorded, *Through the Wire* by Calexico. This album sounds like my life along the Rio Grande, hauntingly beautiful.

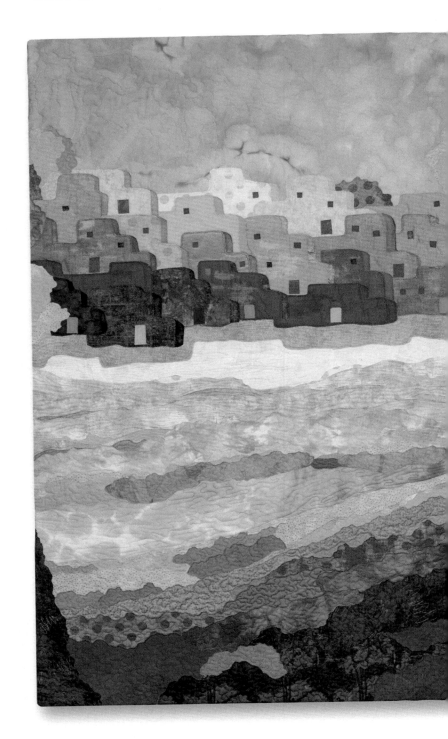

Anita Marsh McSorley
Albuquerque, NM
amcsorley@q.com

Everything about living in the Land of Enchantment excites me and fills me with an appreciation of the history of the land, the diverse cultures, the colors of the landscape and the traditions held dear by its people. I want my artwork to exhibit the joy I feel from being immersed in the wonder of this place.

Made in the USA
Lexington, KY
13 February 2018